DRawing

~ FOR ~

Beginners

DRAWING
~ FOR ~
Beginners

100+ Ideas and Prompts to
Release Your Inner Artist

Jamie Markle

ADAMS MEDIA
New York London Toronto Sydney New Delhi

Adams media

Adams Media
An Imprint of Simon & Schuster, Inc.
57 Littlefield Street
Avon, Massachusetts 02322

First Adams Media trade paperback edition May 2021

For information about special discounts for bulk purchases, please contact Simon & Schuster Special Sales at 1-866-506-1949 or business@simonandschuster.com.

The Simon & Schuster Speakers Bureau can bring authors to your live event. For more information or to book an event contact the Simon & Schuster Speakers Bureau at 1-866-248-3049 or visit our website at www.simonspeakers.com.

Interior design by Colleen Cunningham
Illustrations by Sara Richard

Manufactured in the United States of America

1 2021

Library of Congress Cataloging-in-Publication Data
Names: Markle, Jamie, author.
Title: Drawing for beginners / Jamie Markle.
Description: Avon, Massachusetts: Adams Media, 2021
Identifiers: LCCN 2021000305 | ISBN 9781507215975 (pb)
Subjects: LCSH: Drawing--Technique.
Classification: LCC NC730 .M2925 2021 | DDC 741.2--dc23
LC record available at https://lccn.loc.gov/2021000305

ISBN 978-1-5072-1597-5

DEDICATION

For my parents, who instilled in me a love of reading
and encouraged me to explore my creativity.

ACKNOWLEDGMENTS

Thank you to my partner, Paul, for supporting me and
all my projects, including this book.

And a big thanks to all the artists who have shared
their wisdom with me, especially those who have
written books on drawing and painting.

CONTENTS

INTRODUCTION

Inspired to sketch when you see an intricate cityscape? Find yourself critiquing and revising logos and brand designs? Want to revive a childhood hobby of drawing faces, animals, or nature scenes?

Drawing for Beginners contains more than one hundred prompts encouraging you to practice drawing in fun, stress-free ways, whether you're just starting out or you've enjoyed sketching for years. This book isn't like a strict course with boring assignments—no grades and no judgment will be given, and you'll sketch interesting subjects, like a new logo for your favorite sports team, the scene at a local coffee shop, and a ring of keys. You don't need to share your drawings with anyone else (unless you want to!), and you can use any drawing style you choose.

These prompts are designed to inspire your imagination and give you an opportunity to practice your drawing skills. Each prompt provides the following:

- An explanation of what you'll be drawing
- A simple image to be used as a starting point for your ideas
- Tips on how to take your sketch a step further using more advanced techniques or approaches

Not only is drawing an engaging hobby; it has other benefits as well. Drawing can sharpen your problem-solving and critical-thinking skills as you try different ways of sketching something. It can also improve your health by lowering your heart rate and increasing your ability to focus. Drawing can also give you a sense of accomplishment and happiness as your skills improve.

Use these prompts to set your creativity in motion and start reaping all these benefits. You can work through the book from beginning to end or jump around to whichever prompts inspire you at that moment. Also, feel free to personalize your drawings—think about how you could add details that will make your drawing uniquely yours. You don't need to have any drawing experience to get started—all that is required is a little curiosity, the willingness to try, and the desire to have a little fun while you experiment and learn. Use this book as an opportunity to carve out some time for yourself, enjoy the present moment, and spark your artistic side.

Simply grab a pencil, pick a prompt, and start drawing!

GETTING STARTED

The beauty of drawing is its simplicity—all you need to get started is a pencil and paper. The rest is supplied by your imagination and eagerness to experiment. This section will give you a brief overview of drawing tools and techniques before you begin exploring the prompts.

Drawing Materials

Though you certainly can complete this book with only a No. 2 pencil, you might want to use a few other tools to give your drawings more depth and visual interest:

A high-quality pencil: Pencils come in a variety of lead types. Select a pencil that creates a range of dark and light marks in your drawings. A Prismacolor Ebony graphite pencil or other pencil with thick, smooth, dark lead will work well.

Colored pencils: There are many different brands of colored pencils. Look for a brand that has soft, thick lead with saturated colors (Prismacolor has a wide range of colors and variety packs). Soft lead and saturated colors allow for a wider range of marks that won't bleed through the paper.

An eraser: Most of your drawing will be done freehand. (Be prepared to make mistakes—it is inevitable! Keep an eraser handy and remember to tell yourself that mistakes are opportunities for learning.) A soft, gummy eraser works well for gently lifting pencil marks, and a hard, white eraser works well for removing darker lines. Make sure not to damage the paper when using the hard eraser.

Fine-tipped markers: Use fine-tipped markers to create delicate lines and details in your drawings. Look for markers with a nib size of 01, 03, or 05. The lower the number, the finer the line.

Pens: A wide variety of pens is available to add to your drawing arsenal. You can use ballpoint pens, felt-tipped pens, or any other type you have around your home. Use these to add different colors and textures to your drawing. When combined with pencils and fine-tipped markers, pens can add unique elements to your drawings if used sparingly.

A pencil sharpener: Pencil lead is very versatile, a sharp point can draw a fine line, the side of your pencil lead can draw wide strokes, and a blunt pencil tip is great for making hash marks. Experiment with different levels of sharpness to see what marks you can make. Select a pencil sharpener that won't break your lead, preferably one with an enclosed case so your shavings are collected.

A ruler or straight edge: Again, don't be afraid to sketch freehand. However, if using a tool such as a ruler will help you create the drawing you want, go for it. You could also use the end of a book, the edge of your drawing pad, or any other firm edge you have on hand.

Extra paper: You might also want to have extra paper on hand—to sketch some ideas before you begin, to try some prompts a second or third time, or to expand beyond the boundaries of this book to sketch something larger or in a different direction. Thicker paper is more forgiving than standard printer paper, allowing for more corrections and eraser marks. Drawing paper comes in a variety of weights and colors. A quality sketchbook or journal should have paper that is durable enough for your initial drawing adventures.

Objects to trace: For circles, use a compass or stencil, or trace a round object in the size you want (consider coins, glasses, round plastic lids, etc.). Don't rely on these tools too heavily—your own hand is the best tool you have, and you shouldn't focus too much on everything looking perfect.

Common Art Terms

Following are some terms you'll find throughout this book. These words can help you describe your drawing practice more completely and more accurately.

Background: the distant space in a drawing where objects appear smaller and out of focus. Using a foreground, middle ground, and background can create a sense of depth and dimension to a drawing. A background can also be defined as the space behind the subject of a drawing, helping to provide contrast to make the subject stand out.

Contour drawing: a simple, continuous line that captures the form and image of the subject.

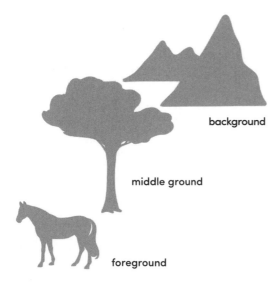

background

middle ground

foreground

Balance: arranging visual elements like line, value, or color in a way to create visual stability.

Composition: how the objects in a drawing are arranged. Before beginning your drawing, think about where you will place the objects you are drawing so that all the elements fit on the paper to capture what you want to draw.

Contrast: the juxtaposition of light and dark used to create interest or dramatic effect.

Cross-hatching: two layers of hatching placed at opposing angles to create value, form, shade, or texture. By varying the size and spacing between the lines, you can create different types of cross-hatching within the same drawing.

Foreground: the space in the front of a drawing; objects appear larger and clearer. See *Background*.

Form: the use of shading to create three-dimensional images and enclose space. Form depicts length, width, and depth.

Gesture drawing: the capturing of the action, form, and pose of a model or subject, often using loose, imprecise lines.

Hatching: fine parallel lines spaced at regular or irregular intervals used to create shading or texture. The closer the lines, the darker the shading will appear.

Repetition: using a single element multiple times throughout a drawing to create unity and rhythm.

Highlight: often the lightest and brightest part of a drawing; it is the spot on an object hit directly by the light source.

Middle ground: the space in the middle of a drawing; objects appear midsize and in softer focus. See *Background*.

Rhythm: patterns or repetitions that create a sense of balance and/or movement throughout a drawing.

Shading: using light and dark values to create form and volume so an object appears three-dimensional.

Shape: the length and width of an object in the drawing. Shapes can be geometrical, but most are amorphous or irregular. Pay special attention to capturing shape— seeing shapes and drawing them accurately helps translate your subject from a three-dimensional object in real life to a two-dimensional image on paper.

Three-dimensional: the illusion of depth or volume in a drawing, often used to make objects appear more realistic by drawing the length, width, and depth.

Value: how light or dark an object or area is. A range of values helps create contrast and interest, and is needed to create shape and form for a three-dimensional effect.

Volume: visual weight or the illusion of having mass by using shading to create form by drawing light and dark areas.

Whimsical: art that is carefree, loose, and often lighthearted. This style prioritizes capturing a relaxed mood over capturing a traditional realistic image.

How to Draw Common Shapes

Identifying and drawing shapes is a foundation to sketching. There are four basic shapes that will help you with your drawing: cubes, cylinders, spheres, and cones. As you imagine what your sketch will look like, try to identify general shapes in the object you're trying to draw. For example, a cylinder can form the structure for a flower stem, and a cone can give shape to a bird's beak. Start by drawing the larger shapes and then move to the smaller ones.

Start your drawing journey exploring these four exercises on a separate piece of paper, and try several variations until they are easy to draw. Once you've completed these, grab your pencil and dive into the drawing prompts.

CUBE

Drawing a simple cube, or a series of cubes, can be the building blocks for a much more complicated drawing. Cubes can lead to drawings of books, houses, and gift boxes. To practice, start by drawing a cube without shading to understand the basic shape, and then you can add shading and shadows.

CYLINDER

Cylinders are used to create rounded objects and are useful when drawing organic forms like arms and legs, tree trunks and branches, and the stems of flowers. They are also found in man-made objects like cans, columns, and drinking glasses.

Use the reference drawing of the cylinder as a guide, and draw a series of cylinders. Draw the first cylinder in three dimensions without any shading. Draw the second one using shading so your cylinder takes on three dimensions.

SPHERES

Spheres are circles that show dimension. The most basic sphere is a ball, but you can use the same drawing technique used to create spheres for other objects with rounded edges, like tires, eyeballs, raindrops, tea bags, clouds, and pillows. These "near spheres" have a lot in common with spheres even if they aren't perfectly round.

Draw a basic sphere like the image shown so you get a feel for how to create a rounded image with your pencil using the shading technique. Next, think of a sphere, like a baseball, and draw that simple shape with details using the shading technique.

CONES

Cones are a less common shape but still useful to understand and utilize when drawing. Cones are most often used when cylinders or spheres come to a point or even a rounded end. You'll find them at the end of a tree branch, a fingertip, the top of a mountain, or a bird's beak.

Finding Inspiration

This book is versatile and meant to encourage you as you begin to draw. You can work through the prompts page by page or jump to the ones that resonate with you. Be patient with yourself as you learn, and celebrate the progress you make.

If you like one drawing prompt and want to try it again—go for it! Use an extra sheet of paper or sketchpad to complete any additional drawings. Think about how you might vary your approach to the same prompt in multiple ways, exploring various techniques or compositions. For example, one drawing may be completed in pencil, while another may use a small amount of color, and a third may be done entirely in color. Or you might choose to draw one of the prompts using simple lines and make a variation with shading to create a more three-dimensional image. The options are only limited by how much you want to experiment and explore.

You may find that you enjoy some of the prompts more than others—and that is okay. Still, try all the drawing prompts, because you may find some unexpected joy or lesson in a prompt that you were going to skip.

Drawing from life, being able to look directly at the object you want to draw, provides the best opportunity to see shadows and shapes and capture them on paper. However, the subjects you want to draw are not always available to you (i.e., you may want to draw a lion or giraffe but not be able to go to the zoo). When practicing your drawing, it is okay to use reference photos for your sketches in this book.

Let drawing help you unwind and relax; spark your creativity in a new way; or honor a special person, place, or thing. Grab a pencil and get sketching!

DELIGHTFUL DAISIES

Artists have been using flowers as inspiration for centuries, and daisies and coneflowers are especially fun and easy to draw. If you have the opportunity to draw flowers from life, study their color, texture, shapes, and shading closely before you begin. If not, follow the simple tips in the sidebar or imagine your own species. Use the circles on these pages to get started, and draw your petals emitting from the circles.

Take It Further Flowers generally have consistent petal shapes but variation in petal size. Petals usually overlap, so consider placing some smaller petals on top and longer petals on the bottom to create a layered effect. Add cast shadows to create a sense of depth to your flowers and enhance the layering effect. Use different colors for different flowers, and add some darker areas and some lighter areas to create contrast.

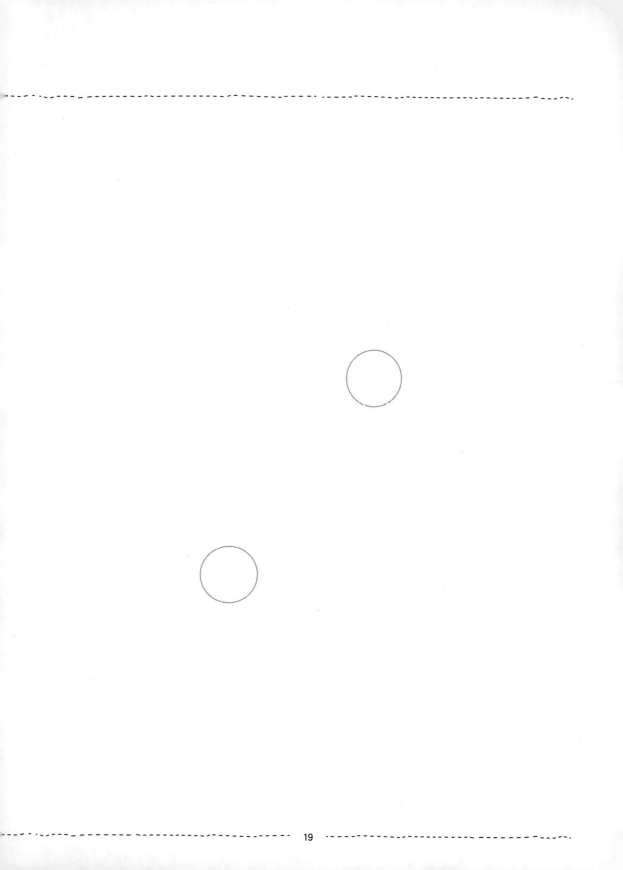

PERSONALIZED NAMEPLATE

You write your name millions of times throughout your life, but have you ever really thought about what your name means to you? Think of images, colors, or other words that describe you. Draw a personal nameplate that captures your personality and style.

Take It Further Draw your name using large, open-box letters. Use the space within or around each letter to draw something that makes you unique or a key characteristic that describes you.

FRAME IT!

Frames don't just decorate and protect artwork; they can be works of art themselves. Design the molding and texture of your own frames using the basic shapes on these pages. Decide if your frame will be wood, plaster, or plastic and how you would draw those textures.

Take It Further Add details to these frames to make them as ornate or visually interesting as possible. For example, you might create a motif to use throughout the frame or design the four corners to be the same to create a consistent look. Once your frames are complete, you can draw your own masterpieces inside. Now that you know how to draw a frame, use this technique to add finishing touches to other drawings.

STUNNING SNOWFLAKES

Snowflakes are made up of basic geometric shapes—such as triangles, diamonds, squares, and parallelograms—that are repeated on each arm. The key to drawing snowflakes is to create mirror images on each arm. For example, if you have a triangle on the top of the right side of one arm, you want the mirror image of the triangle on the left side. Try drawing your own snowflakes here.

Take It Further Think about what shapes you want on the arms of your snowflakes before you draw. Draw one arm first, placing larger shapes at the end of the arms and smaller shapes toward the center. Add other shapes in between. Use a pencil to lightly draw your shapes and make adjustments as you go. When the first arm is complete, replicate those same shapes on the other arms. When all six arms are drawn, redraw your pencil lines with marker to thicken them and make them uniform.

THE GLASS IS HALF FULL

Think positive *and* practice drawing with this exercise. Build on this glass shape to create a beverage filled with ice, a straw, and maybe your favorite fruit wedge on the rim.

Take It Further Glasses are a simple rounded object, which makes them perfect to practice creating form using shading. Determine where the strongest light source is. It is best if you can create your own using a lamp placed to the side so there is a clear light source that will make strong highlights and shadows. Start by drawing the highlights, shadows, and cast shadows to create the form of the glass. Add a long straw resting on the bottom of the right side of the glass and leaning up toward the left (remember a straw is a long cylinder—use the shading technique to give it form). Add ice cubes, which are basically small cubes with rounded edges. Don't forget to add the fluid line near the middle of the glass. Use shading to add a little form to the glass, straw, and ice cubes. Top it off with a lemon wedge or a festive umbrella.

YOUR OWN BOOK COVER

Book covers aim to capture what is within their pages through visual images, colors, and font choices. Think about your favorite story and draw your own cover design on this book cover. Don't forget the title, author's name, and spine. Make up your own story if you don't have a favorite.

Take It Further Before drawing your cover on this book, you may want to play with a couple of different ideas on a separate piece of paper as you figure out exactly what you want to draw. Think about how the title will work with the image. Consider what font and colors you will use. Once your decisions have been made, draw your book cover using colored pencils.

GO, TEAM!

Supporting your favorite sports team is a way to bond with others and build community through a common experience. On these hat templates, copy existing logos, create new logos for your favorite team, or make up your own team and give it a logo.

Take It Further Don't be afraid to erase and make corrections as you develop your idea. Think of how the team's color scheme can help you build a logo and then incorporate any necessary text. Draw your new logo in pencil first, then in colored pencil for a final version. If you're not a sports fan, create a logo for your own arts organization, school, or business instead.

INSECTS, SPIDERS, AND MORE!

Insects are fun and easy to draw because they are made up of basic shapes like spheres and cylinders. They also come in a variety of sizes and colors, providing the opportunity to express your creativity. Draw your own colorful collection of insects and spiders here.

Take It Further Use cylinders, spheres, and lines to create the basic shapes of some of your favorite insects. Draw simple lines for the legs and antennae, and don't be afraid to put your insects to work—maybe an ant is carrying a crumb or a bee is sitting on a flower. Drawing multiples of the same type of object is a great way to create a drawing with a lot of repetition using similar shapes and colors. Think about creating a pattern with your insects (i.e., like you would see in wallpaper) by placing them in an organized, repetitive way on the pages. Use colored pencils to add color, shading, and texture.

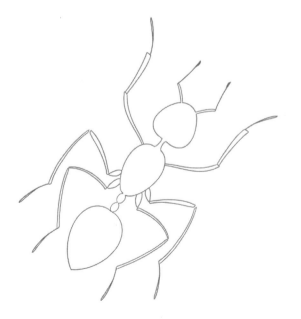

SOUP'S ON!

Imagine the fragrant aroma of fresh soup filling your home. Draw your favorite soup fixings floating in this pot. On the counter, draw the ingredients that make up this soup.

Take It Further Identify your light source or create your own using a lamp to see where the highlights, shadow, and cast shadow are. Use variations of the cross-hatching technique to add form to the soup pot to create a three-dimensional image. If the pot is shiny, it will be reflective; look for the reflections of nearby objects on the exterior of the pot and include them in your drawing. Try setting a pot on your kitchen counter to look for the reflections and highlights. Add color to your soup ingredients for visual pop.

FRUIT BOWL

Use this empty bowl to draw a collection of nutritious and delicious fruit. Experiment with different colors and textures to create a visual feast.

Take It Further Start by drawing basic shapes to represent a variety of fruit, and use the hatching and cross-hatching techniques to add shading and texture. For example, a simple sphere can be used for most fruit—oranges, apples, grapes, persimmons, and so on. Bananas are cylinders bent at the ends. Use colored pencils, a felt-tipped pen, or a ballpoint pen to selectively color portions of your drawing.

THE ROOM YOU'RE IN

Subject matter is all around us—you just have to stop and look. Try drawing the room you're sitting in right now.

Take It Further It may be helpful to create a "viewfinder" using your thumbs and forefingers to crop your room and decide what to draw. Connect the tips of your thumbs to the tips of your forefingers so they touch and form a rectangle. Move your finger viewfinder around the room until you find a view that appeals to you. Begin your drawing by capturing key shapes (a cube for an upholstered chair, a cylinder for a lampstand, and a cone for the lampshade).

GIVE YOURSELF A HAND

Hands are fascinating subjects—so complicated, agile, and versatile. Plus, hands and fingers have volume and many interesting lines and creases to draw. Draw your hand in the space here. If you want a challenge, try using the contour drawing technique.

Take It Further Contour drawing uses simple lines to draw the form of the subject without taking your pencil off the page. To try it, hold your nondominant hand in front of a blank wall or above a table. Use a pencil to draw your hand, starting at the wrist. Imagine the pencil is touching your hand, and slowly draw up the back of your hand, drawing any veins or creases you may see. The trick is to keep your pencil on the paper at all times—no lifting—so that you create a continuous line throughout the entire drawing. It is okay to draw on top of lines you've already drawn as you capture the contour of your hand. Try to end back at your wrist. When you've finished, give yourself a hand!

GROW WHERE YOU'RE PLANTED

Use these pots to draw three different types of houseplants. Each plant should have a uniform leaf that is repeated again and again. This repetition of the same type of leaf can be fun to draw as you master the basic shape but play with color and size.

Take It Further Drawing three plants will give you the opportunity to practice drawing different shapes as you experiment with a variety of leaves. Some plants are tall with long leaves, some have cascading leaves that dangle or crawl, and some are dense and bushy. Vary the size and direction of the leaves in each plant. Embellish the pots to complement your plants.

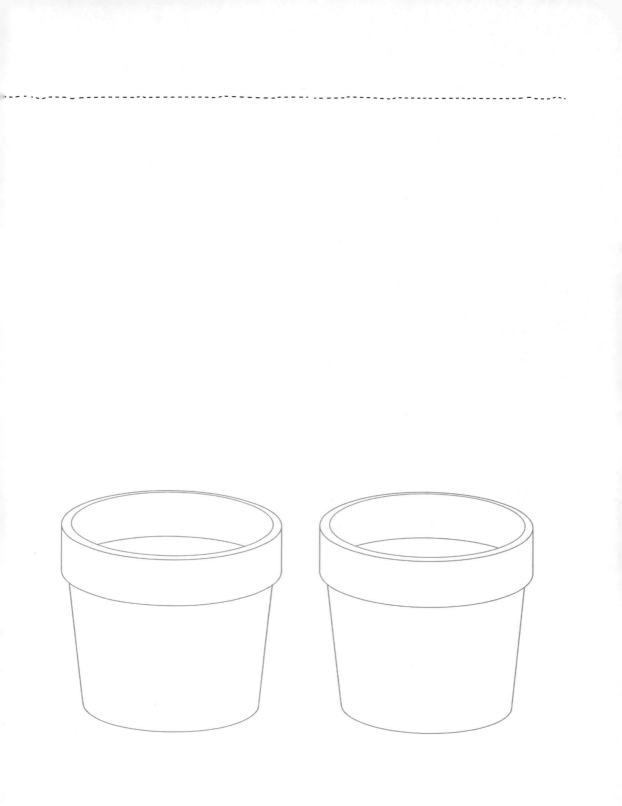

PROTECTIVE TALISMAN

Talismans are spiritual objects (often circles) inscribed with words or images and sometimes featuring gems or rocks that are said to bring luck, keep away bad energy, or just add a little personality to your key chain. Use the circles on these pages to draw talismans for yourself, a friend, or a relative.

Take It Further To plan out your talisman, seek inspiration from feathers, old coins, ribbons, string, gems, or stones. Are the surfaces smooth or rough, dull or shiny? Do any of your items have words on them like "trust," "believe," or "peace"? The items you draw can radiate from the circle or be designed to dangle as if on a key ring. Use color to add some extra magic to your talisman.

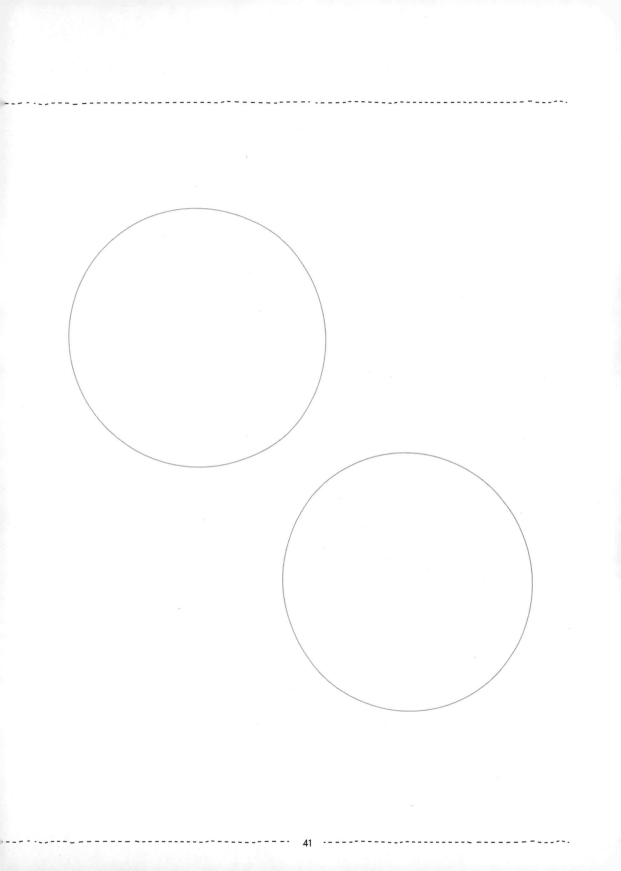

WHAT'S INSIDE?

Imagine peering through this window into your home. What would you see inside? Draw that interior scene.

Take It Further Create a sense of depth to your drawing by creating a foreground, middle ground, and background. Look for the darkest and lightest areas in the room to help define the values within the space to guide you as you draw shapes using the shading technique to create a three-dimensional image. Draw the images in the foreground first, then the items in the middle ground, followed by what's happening in the background.

LOOK OUTSIDE

Which window in your home presents the best view? Look out that window and draw what you see—or look in your mind's eye to draw any outside view.

Take It Further As you compose your drawing, remember to include the foreground, middle ground, and background. Objects that are closer to you will be clearer and larger. Objects should look smaller and less clear the farther they are from you.

SILVERWARE PICK-UP STICKS

Collect a handful of silverware, drop it on a place mat, and draw! The more pieces of silverware you use, the more opportunity you'll have to create an interesting drawing.

Take It Further For a challenge, use a pencil and the contour drawing technique to draw your arrangement. Once the line drawing is complete, add shading to some areas or use a different color to fill in the negative spaces—the space between the objects where nothing exists—created by the silverware. Add a pattern or fringe to your place mat to make it more decorative.

HIT THE SLOPES!

It's time to get a little fresh air and enjoy the winter weather with a ski trip. Draw your skiers as they propel down the mountainside.

Take It Further Most people draw snow as pure white, but if you look closely, you will notice many variations of value and color. Add some blue and gray values in your snow scene to create a more interesting and accurate visual effect. Change the values as you use the shading technique. Keep the color variations subtle and similar throughout the drawing. Add a pop of color for a little drama to your winter landscape. Try to capture the cool winter air and crisp light that the season offers.

YOU'RE A WINNER!

And now you can create your own medal to prove it. Think what medal you want to win—would it be an achievement in sports or academics, or for a particular hobby or passion? What does the ribbon look like? What are the edges like? Draw first-, second-, and third-place medals.

Take It Further Medals, like coins, use the bas-relief method of sculpture. Bas-relief sculptures are shallow, with very little difference in depth, and are best drawn with crisp lines using a sharp pencil. Redraw your pencil lines with a fine-tipped marker when you have finished your drawing. Have fun with the color of the ribbons using colored pencils.

CANDY BARS

Candy bars deliver a powerful punch within a small package—not just the candy, but the wrappers are often bold and colorful too. Treat yourself to a couple of your favorite candy bars and use them as models for your next drawing.

Take It Further Think about the text on the candy wrapper as shapes, not words, to better understand how all the shapes work together to form the design of the wrapper. Use a pencil to draw the large shapes first, followed by the smaller ones. Use bold colors or values to create strong contrasts in your drawings.

STOKE THE HOME FIRES

Warm yourself with a fire by drawing logs, flames, and ash. Consider adding some decorations or other fireside elements around the hearth.

Take It Further Fire gives off light, making it the brightest part of a drawing. To make something appear bright, your drawing will need some very dark elements next to the lightest part to create a strong contrast.

YOUR DREAM HOUSE

For this prompt, you're an architect and artist! Use this rectangle as a foundation for drawing your dream home. What style of home do you want to draw—Arts and Crafts, Victorian, contemporary, or midcentury modern? Include details that make your house fit the style you choose.

Take It Further Think about what colors and drawing style will best capture your dream house. Start with a pencil drawing, and then select colors that match the style of home you draw. Consider an earthy palette for an Arts and Crafts home or a bright color scheme for a Victorian Painted Lady.

DOODLE ALL DAY LONG

Most people think of doodling as something you do during a meeting or while chatting on the phone. However, doodles are a great way to play with lines and other simple shapes. Doodle your favorite shapes, images, or types of lines within these pages.

Take It Further Experiment with doodling different lines and shapes (circles, diamonds, triangles, etc.) to fill the notebook drawings on these pages. Add color in the spaces in between the shapes to create some depth and variation.

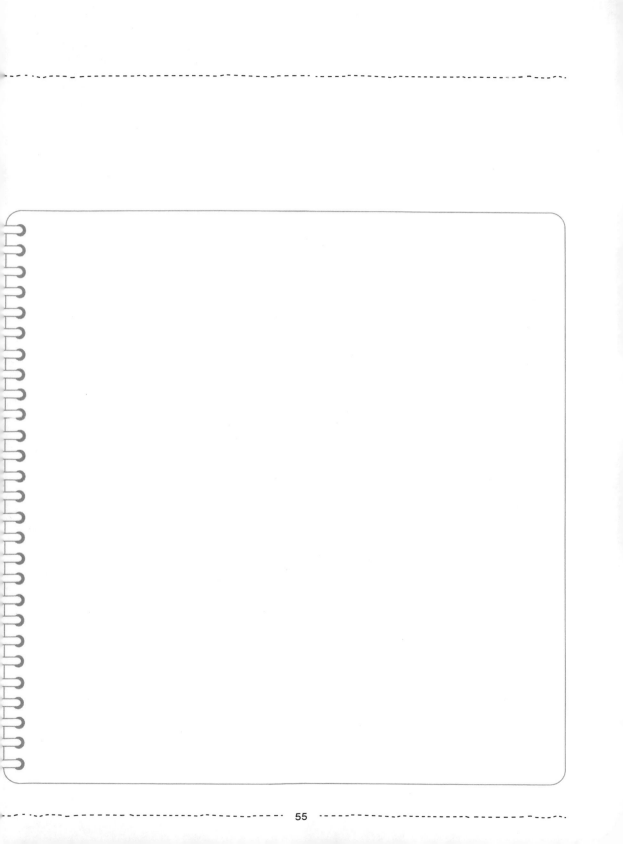

WINE LABELS

Even if you aren't a wine connoisseur, you can appreciate the beauty of the bottles and labels that are found at the local wine shop or grocery store—the variety is endless! Drawing labels is a great way to combine text and images into a single work of art. Labels can be fun, serious, austere, or complex. Design your own line of wine labels to suit your personal vintage.

Take It Further Think about the name of your custom wine. What image best represents that name? What type of font will capture that name and image and, more importantly, the essence of your wine? On a separate sheet of paper, list out all the elements and then draw them on the wine bottle. Don't stop there—create an entire line of fine wines by completing all of the images on these pages.

CATS ON A LEDGE

Cats are dynamic creatures able to complete amazing physical feats, making them interesting subjects to draw. Use reference photos of your favorite feline model and draw a series of cats on top of this wall. Draw two or three cats in different positions, like sitting, sleeping, jumping, or walking.

Take It Further Grab a pencil to draw a quick sketch that you can develop into a more complete drawing. Make basic shapes like spheres for the heads, cylinders for the bodies and limbs, and cones for the ears. Use the shading technique to add form to your basic shapes.

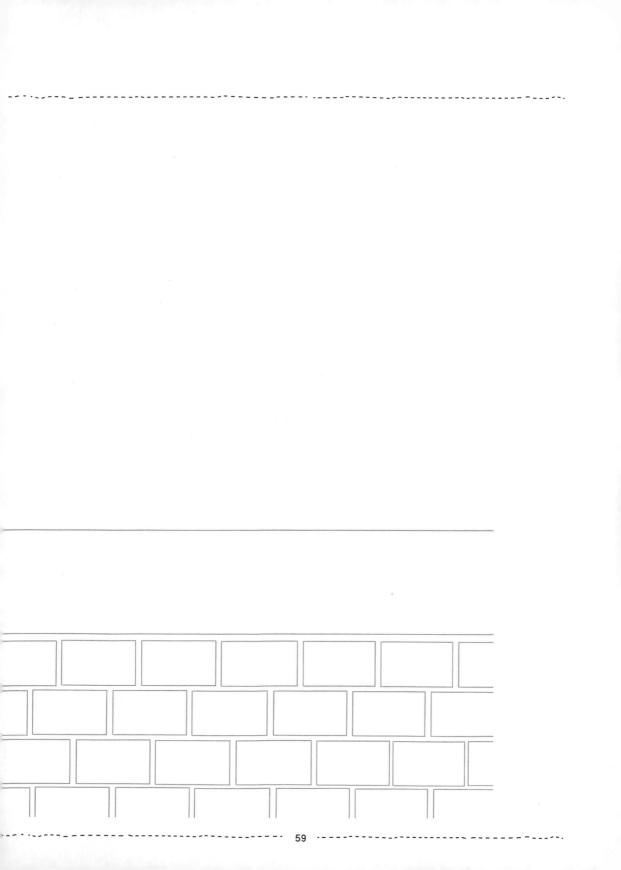

RAINY DAY MONTAGE

Rainy days mean more time inside, so they are perfect for practicing your drawing. Use the umbrella as inspiration and draw some items you may need for a rainy day under it. Consider adding boots, a rain jacket, puddles, or a rain hat—whatever will make your rainy day a little better!

Take It Further When drawing a montage—an assortment of various images—keep the drawing style similar. If you draw the images in the same manner, they will create continuity in your drawing for a more unified or harmonious look.

I WISH I HAD...

Everyone has goals and aspirations to make life better. What is on your wish list? Draw the things you wish you could have or the goals you'd like to achieve.

Take It Further You can tell your story through different types of drawings. You can draw a single item that represents your goal, a scene that captures your dream, or several smaller objects that tell the story of your goal.

FACE IT!

Faces can be as complicated or as simple as you want to make them. The important thing is to capture the person or the mood they represent. Draw a series of faces that show a variety of emotions using these simple outlines.

Take It Further The face contains forty-two muscles that help convey different expressions and emotions. Consider drawing a face that is upset, surprised, happy, sad, confused, or worried. Use a mirror to study yourself making a variety of expressions, and then try to simplify those into just a few lines to draw the eyes, nose, and mouth. The face is complicated, but if you think about it as a series of little drawings that make up a larger drawing, it is much easier to draw. Look for the basic shapes and how the light helps create the form for each of the facial features (eyes, nose, mouth, ears, etc.) as you draw. After you finish the face, sketch in the ears, eyebrows, and hair. If you want to draw the face using the contour drawing technique, that approach is good too!

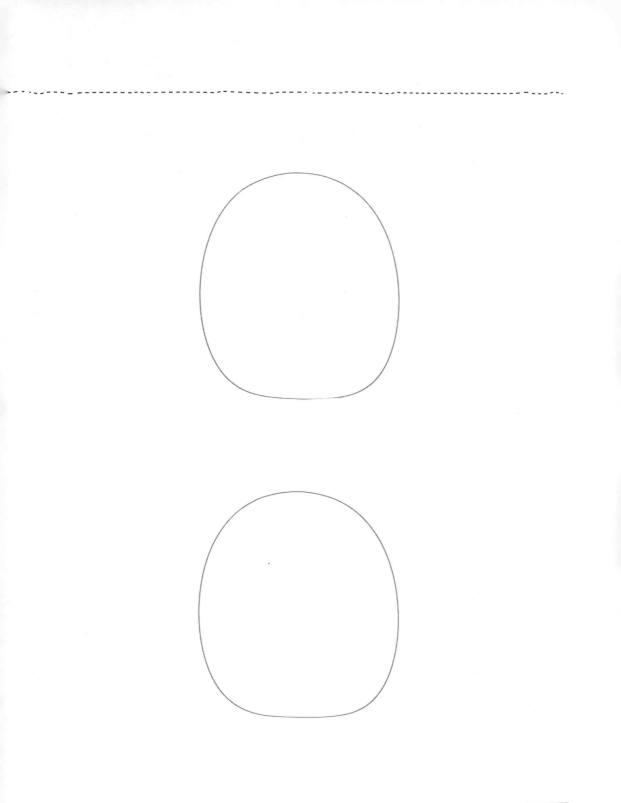

SPECIAL DELIVERY!

Postage stamps come in a wide variety of designs and colors—in fact, each one is a miniature picture captured in a simple rectangle (or sometimes a circle). Use these frames to re-create some of your favorite stamps or design your own.

Take It Further Begin your drawings using a sharp pencil—when spaces are small, you want a very fine tip (keep your pencil sharpener handy!). Add colored pencils for a little color to make your stamps pop, or use a fine-tipped pen to create a simple, crisp black-and-white version—add variety to these pages by trying each approach or a combination.

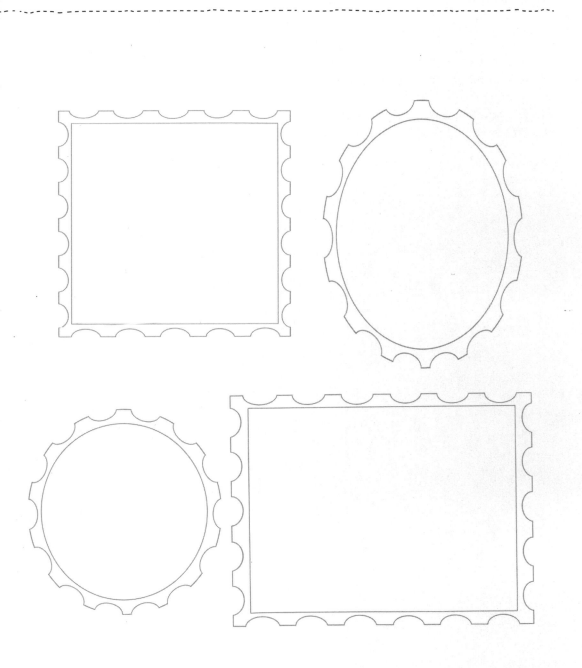

BIKE DESIGN

Bikes are a healthy and eco-friendly way to get you from point A to point B. They can be built for speed or racing, used to make deliveries, or can be a way for the family to enjoy the afternoon together. Imagine how your dream bike would look and draw it using the wheels on the page.

Take It Further Be sure to include the frame, seat, handlebars, and wheel details. Consider if you want to include a basket in the front or back. Decorate your bike however you want, adding color and details.

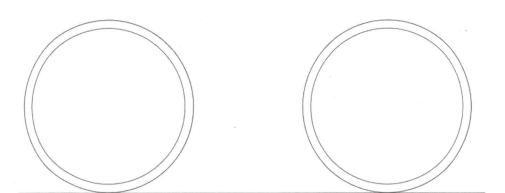

PARTY TIME!

Everyone loves a good party—tasty food and drinks, music, party lights, and games. It's time for you to become the party planner and create a festive atmosphere by drawing a piñata! Pick a meaningful animal or object and draw that as a festive piñata—maybe a traditional donkey or a cat, dog, martini glass, or car.

Take It Further Once you have determined what you want your piñata to be, draw it on the end of the string. Keep in mind that most piñatas are boxy replicas of the objects they represent, so consider using some of the basic shapes like cubes or cylinders to get started. Use colored pencils to brightly decorate the details of your piñata. Draw some party lights using simple shapes like cubes and spheres in various colors to adorn the string. Add candy or other gifts on the ground below.

PEACE IS...

Everyone needs to escape our chaotic world and recharge sometimes. What place, words, or mindset bring you peace or make you peaceful? Think about what brings you peace and draw it within and around these symbols.

Take It Further Peace can come in different forms—if you have more than one thing that brings you peace, draw several of them. Think carefully about what colors represent peace to you and use those in your drawing.

WORK IT!

Try your hand at fashion design and create a stunning wardrobe! Consider drawing evening wear, casual wear, business wear, athletic wear, or whatever type of clothing speaks to you. Use the four hangers to display your collection.

CHERISHED PET

Pets provide companionship and energy to your household. Celebrate a beloved pet by drawing them here, near their food or water bowl.

Take It Further Before you begin, look closely at the colors and textures that make up the fur, scales, or skin you'll be drawing. Pay special attention to the eyes, which help convey personality. An eye is a sphere and will contain a highlight where the light is the strongest and reflects off the eye. Placing the highlight is key—look at your pet's eye or use a reference photo to capture this accurately. Use a pencil to draw your pet and then add details with colored pencils.

A PICTURE-PERFECT FAMILY

Family can be the people you grew up with, the people who live in your house, or a chosen group of people who support and care for you. Draw your family portrait and capture the personality of each person as you see them.

Take It Further Drawing from memory is one way to approach this prompt, but you can also use a photo of your loved ones if you want to capture an accurate likeness. Don't forget to add any pets who are part of your family.

CLOUDY DAYS

Clouds contain a variety of shapes that can inspire creative drawings. Go outside and look up into the sky to see what images you can see. Once you find an image you like, add it to this sky.

Take It Further Pay close attention to the different values of clouds to capture their shape and form. Use a pencil or gray-colored pencils in various shades to create a range of values. Clouds are soft and billowy; use the cross-hatching technique to create form and add some dimension. Storm clouds will have a greater range of values with more contrast between the darks and lights.

GRAPEVINE TWISTS

Add leaves, grapes, and a few tiny bugs to this grapevine to make your own vineyard. Draw the details in the leaves and fill the pages with a grapevine that is thick and overgrown.

Take It Further Grapes are elongated spheres, while grapevines are thick meandering cylinders. Add additional lines to extend your vine, filling the pages with grapes, leaves, and insects. Use colored pencils to add subtle, earthy colors.

TRIP TO THE COFFEE SHOP

Nothing provides a little pick-me-up like a cup of coffee or tea. Design your own café here, making it any style you choose. Don't forget to name it!

Take It Further Looking through a window provides a natural picture frame for the activity inside. Draw the items in the foreground first (i.e., tables in front of the windows with mugs and cups), followed by the items in the middle ground (what's on the counter where you order?) and the background (shelves or a wall).

APP DESIGN

Modern technology is a constant companion for contemporary life. Look at your phone and either draw or redesign the app icons you use most frequently to create your customized phone home screen.

Take It Further Phone icons are small, rounded squares that convey meaning with simple shapes and colors. The icon images are shapes (i.e., a boxy camera) within another shape (rounded square) within another shape (the phone). Use a very sharp pencil to draw the icons since you're working within a small space. Use colored pencils to add the bright, saturated colors for each icon. Don't forget your wallpaper behind the app icons!

CAN IT!

Glass jars are used for canning, as well as storing small items found around the house, kitchen, or office. Fill these empty jars with your favorite food or household items like buttons, paper clips, computer cords, candy, bottle caps, or pocket change.

Take It Further When drawing something behind glass, work from the outside in. Before drawing what's in the jar, think about what the outside of the jar looks like. Capture any reflections or colors or the texture of the glass and draw that first, and then draw what's inside. Reflections are images captured on a shiny surface; they are usually close in value to the reflective surface and slightly distorted. Approach reflected images as small, subtle shapes within a larger shape of the jar.

HAPPENING HAIRSTYLES

Draw different hairstyles on each face—try long, short, curly, or straight hair. You can opt for classic options or think of some outrageous examples if that's more your style.

Take It Further Drawing hair is all about capturing texture and color. Use a pencil to draw the major shapes of each coif and then add detail using very sharp colored pencils. Don't try to draw the individual hairs, but start with the shape of the hair and then add texture to convey how it will look. Use your own image in a mirror or ask a friend to pose for the best opportunity to learn how to draw hair.

AND...SCENE!

Everyone has a favorite TV show, whether it be from a network, cable, or streaming service. What do you like to watch: comedies, dramas, true crime, or cooking shows? Draw a memorable scene from your favorite show.

Take It Further To capture an image from a flat screen or even a photograph, first look for the shapes, lightly drawing the larger shapes first and then the smaller ones. Once the shapes are identified, look for the light and dark values that create contrast and form. Once these are identified, it is easier to replicate the image by using those shapes and values to re-create them through the shading technique.

GAME OVER

Go retro! Think of a classic video game and draw the details on this arcade game. Draw the simple graphics on the screen and decorate the outside of the machine.

Take It Further Video games from the 1980s had one thing in common—all the images were made of large, blocky pixels. Draw your video game using a lot of squares to replicate this retro feel.

BIRDS ON A WIRE

Birds offer us the opportunity to see natural flight in action as they soar through the air. Draw several variations of birds here, with some resting on a wire and some in flight or coming in for a landing.

Take It Further When drawing birds, start with a large oval for the body and a small oval for the head and a cone for the beak. Try positioning the heads differently so your birds are interacting with one another. Draw the beak, wings, and eyes. Finally, add feathers, thinking about the texture and small details.

BUSTLING BOUQUET

Flowers can brighten even the dreariest of days. You may not have a garden or be close to a floral shop, but you have pencils, paper, and your creativity. Use the vases to draw your own bouquet of flowers to add some color and cheer to these pages.

Take It Further When drawing cut flowers, start with the stems and work your way up and out. Consider drawing several of the stems first to plan which direction you want your flowers to point. Add the flowers at the top of the stems. Draw various types of flowers in your vase, such as roses, daisies, tulips, or other favorites. Add some leaves or other foliage for variety and texture. Use colored pencils to add pops of color to your arrangement.

RING OF KEYS

Ordinary items can provide extraordinary drawing inspiration. Keys are one of those items—they're readily available, and they contain a lot of interesting shapes and spaces to draw. Use this key ring to draw a set of keys within this box.

Take It Further Lay your keys on a table and arrange them so that they are spread out, with their unique shapes visible. Using a pencil, draw your keys and the items on your key chain using the contour drawing technique. Plan your drawing so the keys reach the edges of the square on the page. Elongate the keys if you need to—don't be afraid to take a little artistic liberty.

A TREASURE HUNT

Design your own treasure map using this outline. Think about where you want your adventure to begin and what type of hazards are found on the path to the final destination.

Take It Further Drawing a map is a combination of sketching small drawings and adding some text. Place the important parts of the map first (the starting point, end point, and any main challenges or highlights). Then add other details and points of interest. Think about what type of text should label the different aspects of your map.

KITCHEN UTENSILS

Kitchen tools are really interesting subjects for drawing. Select some of your favorite kitchen utensils, put them in a short jar, and get cooking, er, drawing.

Take It Further Kitchen utensils have varied shapes and heights, and provide an opportunity to practice both contour drawing and shading techniques. Try this drawing two ways. First, create a contour drawing of the utensils as they appear, capturing all the lines and details in the first jar. In the second jar, create a more complex drawing using the shading technique to create form.

MANDALA DRAWING

Draw a mandala using the same shape more than once and only two or three colors to create unity and harmony within your mandala. Create a personal mandala for various aspects of your life—work, home, family, recreation, and so on.

Take It Further Mandalas are geometric symbols used in various religious traditions and expressed through different artistic styles. You might want to look online at mandala designs to spark your creativity. Break up the space within your circles by using simple shapes (such as smaller circles, squares, triangles, or lines) repeated to create a rhythmic pattern. If those shapes don't resonate with you, try using more meaningful images, like flowers, the sun, leaves, stars, or arrows.

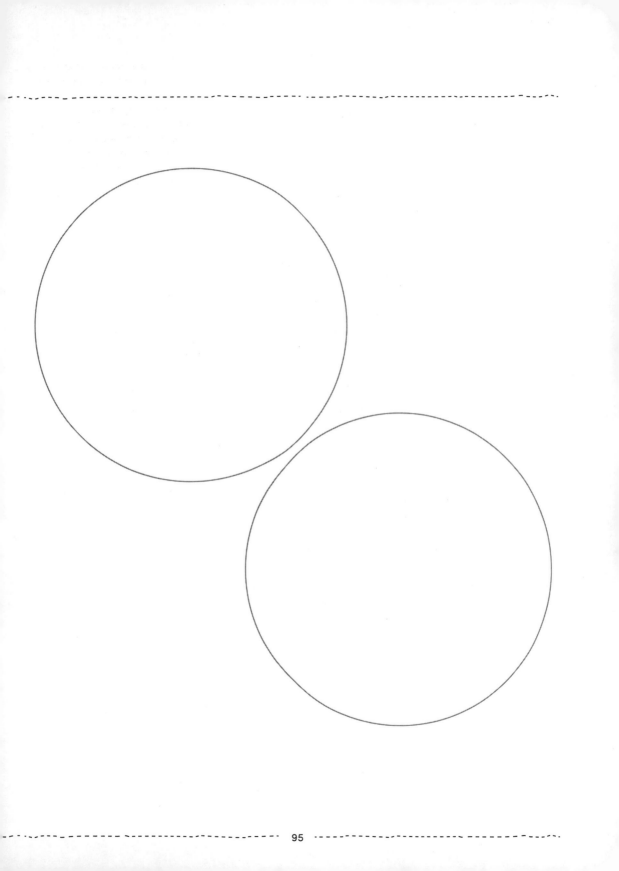

THE ICING ON THE (CUP)CAKE

Draw icing-covered cupcakes with sprinkles, piping, and other toppings to make some visual treats good enough to eat. Serve them up on a plate or platter.

Take It Further Think of your cupcakes as a set. Create a color theme to use on all of them, but make each one unique by using different designs and color placement. Don't forget to add details to the sides. This drawing could use the shading technique to create a three-dimensional effect or could be made up of delicate, carefree lines with no shading for a more whimsical approach.

HANGING GARDEN

Hanging plants often have long, trailing vines and flowers that reach down to the ground. Use these hanging pots to draw a drooping plant thick with flowers.

Take It Further Draw the vines, add flowers, and then place them at regular intervals to create a rhythmic pattern. Place the leaves more randomly to add variety. Use the same shapes throughout the drawing to create harmony and unity. Add details to the flowerpots to make each one unique.

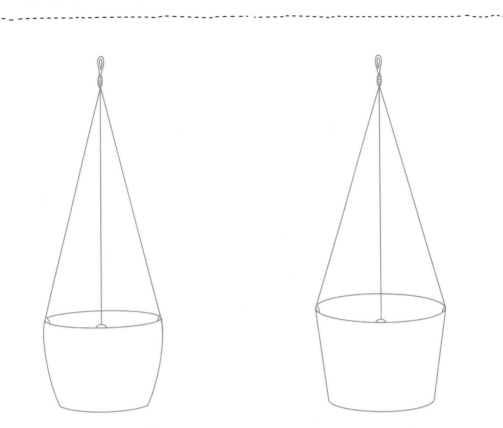

AT THE FARMERS' MARKET

Fresh produce doesn't only nourish the body; it can also nourish the soul. Pull some of your favorite fruits and vegetables from your refrigerator or pantry and set up a colorful cornucopia for this drawing.

Take It Further Use your pencil to draw basic shapes like spheres, cylinders, and cones to fill the grocery bag with healthy foods. Capture areas of light and dark to create accurate shapes. Use the hatching and cross-hatching techniques to add some form and volume. Finally, add bright, vibrant colors using felt-tipped markers or ballpoint pens.

START YOUR ENGINE!

Cars represent speed and freedom. Design your dream automobile by thinking about the shape of your car and what color you want it to be.

Take It Further Start by sketching the basic shape of your dream car using a pencil, adding details such as headlights, wheel rims, and other styling as you go. Go over the pencil lines with a fine-tipped pen or marker. Add color and action lines beneath and behind the car to show speed.

DOG FACES

Dogs are loyal family members who bring comfort and happiness with their expressive faces and amiable companionship. Use these pairs of circles to draw the eyes and then faces of a few precious pups. Try to show different emotions and breeds.

Take It Further When drawing any type of face, pay particular attention to the eyes, which convey a range of expressions and emotions. Human eyes have smaller pupils and show much more white than dog eyes, which contain large pupils and very little white. Colored pencils are great for drawing eyes so you can re-create a range of colors and values in the irises. Look for the highlights in the eyes to help create the rounded shape of the eyes (remember, eyes are spheres). Look to your own pet or use the Internet to find images of dog faces you want to draw.

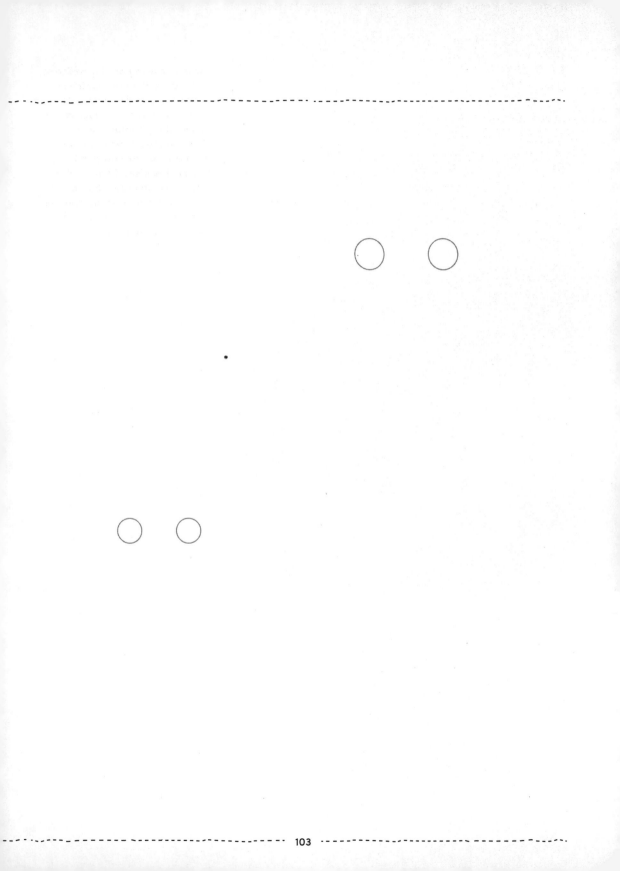

LANDSCAPE

Landscapes are one of the most popular drawing subjects—probably because people love nature, and landscapes offer an endless opportunity for variation and creativity. Think of the elements in nature you enjoy seeing, smelling, touching, and hearing—add them to your landscape until you have a rich and expansive scene.

Take It Further A blank page can be intimidating—but don't let that stop you from putting pencil to paper. The starting line of this creek will give your composition a little drama and will activate the page. In the front right portion, draw a close-up view of what your landscape might contain—perhaps grass, rocks, or flowers. On the other side of the creek, draw things you may see farther away, such as trees, bushes, a house, a swing, a picnic—whatever you want to include.

SPACE ADVENTURE

Are you ready for liftoff? It's time to take your imagination far from planet Earth and draw an outer space adventure using this moon as your lunar base.

Take It Further Drawing outer space is similar to drawing a night scene—there is no atmosphere to reflect the sunlight, so the area above the moon will be dark. Draw your collection of space objects—spaceship, stars, or astronauts—and then fill in the background to create a dramatic effect. Your objects will pop off the page if you use light colors to contrast with the dark night sky.

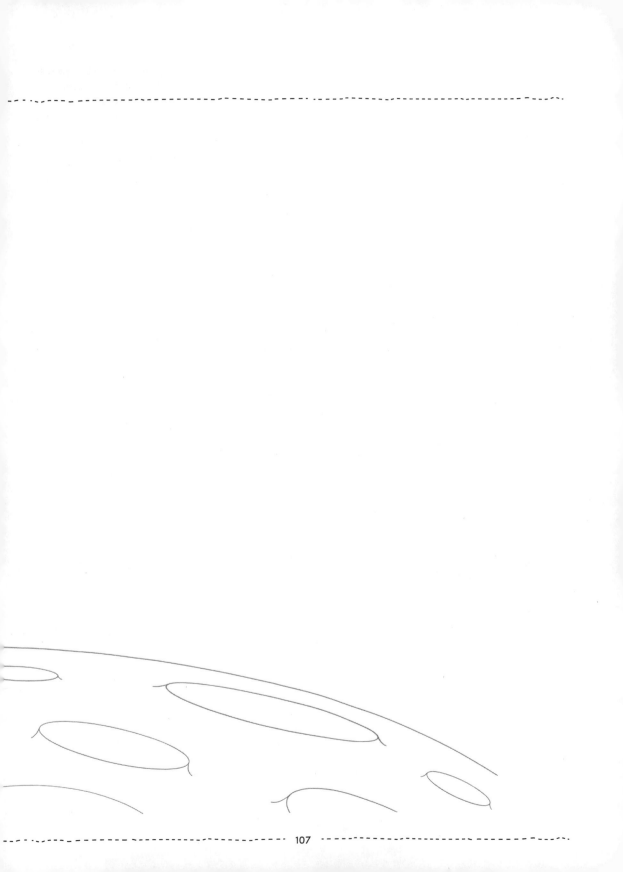

EARRING DESIGN

The ability to accessorize allows people to express themselves through small but powerful statements. Design a few sets of earrings—each one making a unique statement—and draw them in these jewelry boxes.

Take It Further Consider drawing beads, metal filigree, a series of hoops, or an intricate pattern when designing your earrings. Use a pencil or fine-tipped marker to draw the details. Metal surfaces are highly reflective, as are gemstones, so determine the light source and how the light will hit the earrings to reflect the highlights.

MIRROR, MIRROR

Self-portraits allow you to celebrate the best model available—you! Sit or stand in front of a mirror and draw a self-portrait. You can sketch a simple line drawing using pencil or marker or draw a full-on color portrait using colored pencils.

Take It Further If you're not sure where to begin, start with a simple contour drawing of yourself—keep it simple and just show your bust (a drawing that captures the top of the head down to just below the shoulders). If you don't want to use the contour drawing technique, break your face down into different elements and draw each one individually. Draw multiple versions with variations that capture different expressions, profiles, and positions. Emphasize two to three unique characteristics that capture the real you.

MORNING MOTIVATION

What motivates you in the morning: meditation, exercise, a paycheck, a warm beverage? For most people, coffee or tea is *the only* way to start the day, since the warm liquid and comforting caffeine warms the body and activates the mind. Fill this mug with your favorite morning brew.

Take It Further Create a more interesting composition by accessorizing your drawing with things you use to make coffee or tea (spoon, creamer, sweetener, napkin, flavoring, etc.). Your accessories can be next to or inside your mug. Liquids can be tricky to draw, as they are both reflective and prone to motion. Liquids most often have a highlight where the liquid touches the edge of the glass or mug. Fill a mug with water, coffee, or tea and look for the highlights or any reflections that may appear in the liquid.

FABULOUS FABERGÉ

The House of Fabergé was famous for their jewel-encrusted eggs and other decorative objects. Try your hand at drawing a set of ornate, embellished eggs to rival these famous masterpieces. Think big and gaudy, and don't be afraid to go over the top!

Take It Further Consider drawing some gems on your eggs. To draw a cut stone, use rectangles, parallelograms, and triangles to create cube-like shapes to make them appear three-dimensional. Use rich and deep colors with contrasting highlights to create a reflective surface. Determine where the light source is to draw a few reflective highlights on the gemstones, and remember the highlights will be the lightest part of your drawing and should appear near the edges of the cut stones.

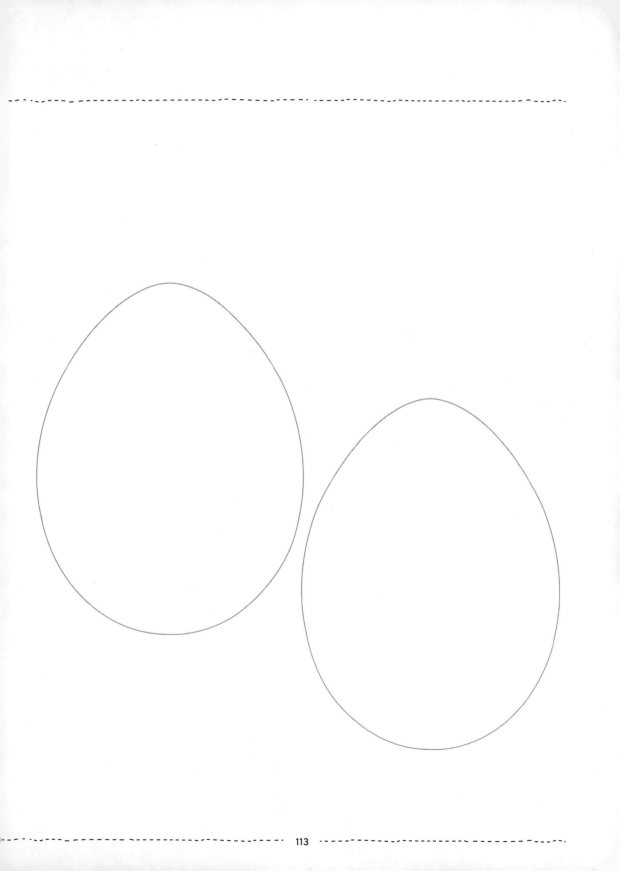

NIGHT MOVES

Some cities never sleep, busy with people still out and about. Think about your favorite nighttime activities and draw a nocturnal scene capturing the nightlife of a city.

Take It Further A nocturne is a painting or drawing depicting a night scene. Nocturnes are an opportunity to use deep, dark colors to create moody atmospheres. Limit how many light and bright colors you use—call on them sparingly to create contrast and add some "pop" to your drawing.

CREATIVE COOKIE

Cookies have become more than delicious dessert items; they are now works of art. Design and decorate your own cookies—you'll not only have fun drawing; you might also be able to use your ideas the next time you bake.

Take It Further Use pattern and repetition to create variety and unity for your cookies. Pick one or two motifs—decorative designs or patterns—and repeat them on each of the cookies; use a limited color palette (two to three colors maximum). By limiting your motifs and colors, you create repetition and unify the design for your cookies.

PERSONAL LOGO

Logos are a visual representation of a company, idea—or even a person! What makes you special? What colors or shapes represent who you are? Brainstorm an image that captures your essence, design a logo that shows who you are as a person, and then draw it on this T-shirt.

Take It Further Using a pencil, plan your logo on a separate piece of paper before you draw it. Keep your logo simple, clear, and memorable. Once you have your design, draw it on the T-shirt using colored pencils.

BUILD A SANDWICH

A delectable deli sandwich can provide inspiration for a unique and mouthwatering drawing. There are so many textures and layers to draw—think of meats, vegetables, and condiments. Draw a deli sandwich that is good enough to eat!

Take It Further Think about the different textures for each layer and how you might draw those to represent the different foods. Foods that have higher levels of moisture will be more reflective (lettuce, tomatoes, condiments) and have stronger highlights. Foods that are dryer will be less reflective (bread), and foods that have a moderate level of moisture will be somewhere in between (cheeses, meats). Consider what order makes sense and will allow you to put all of those things in your drawing. Add as many layers as you like.

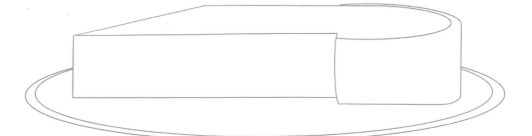

AT THE BEACH

Draw a perfect beach day, including all the fun items and activities that are part of a trip to the shore. Consider a beach ball, volleyball, pail, shovel, sandcastle, flip-flops, and some beachgoers.

Take It Further The horizon is the point where the sky meets the ocean—this will be the farthest point of your background. Use the line on this page as your horizon line to start your beach scene. Draw a line where the sand meets the ocean using your pencil about halfway between the horizon line and the bottom of the page. Draw your beach activities and objects in the ocean and on the beach. The bright sun will make objects appear brighter, so keep your values light.

HOW DOES YOUR GARDEN GROW?

Gardens filled with flowers and shrubs provide colors, scents, and shapes as inspiration for artists and nature lovers. Think about your favorite plants and flowers and draw them in your garden.

Take It Further Colorful flowers can dazzle, while lush greens provide contrast to those bright colors. Give your garden drawing various colorful flowers for interest and some quieter green areas to give the eye a rest. Use colored pencils to add color.

MOVIE MADNESS

Movies can delight, excite, and inspire us to see life through the eyes of cinematic characters with compelling stories to tell. Think about your favorite movie. What scene inspired or moved you the most? What about this movie brings you back to view it again and again? Draw that moment here.

Take It Further Imagine the movie stopping so you can see a single picture, capturing that specific moment in time. Think about what shapes and colors were used to create the movie scene and draw them. Try to capture the mood and energy of the scene with your color palette. If you need inspiration, watch your favorite movie again and pause the screen on the scene you want to draw for reference.

FAVORITE MEMORY

Think about something that made you happy as a child—a birthday present, an event, a special day, a family vacation, or a holiday—and draw that memory in the photo frame. Add a label in the space below the picture to record your memory.

Take It Further Instamatic cameras were popular for how quickly an image could be printed and the unique color quality of the photograph. Experiment here using a limited color palette—one that's vibrant, sepia-toned, or in shades of gray. Limited palettes can create mood by focusing on a range of cohesive colors that convey a similar feeling.

HARD CANDIES

Avoid all those calories and sugar and satisfy your sweet tooth by drawing candy instead of eating it!

Take It Further Use a pencil to draw designs, patterns, and colors on the candy wrappers. Make some wrappers bright and shiny and others dull and matte. Draw additional candies in between the ones on these pages, filling up the blank space with an array of sweet treats.

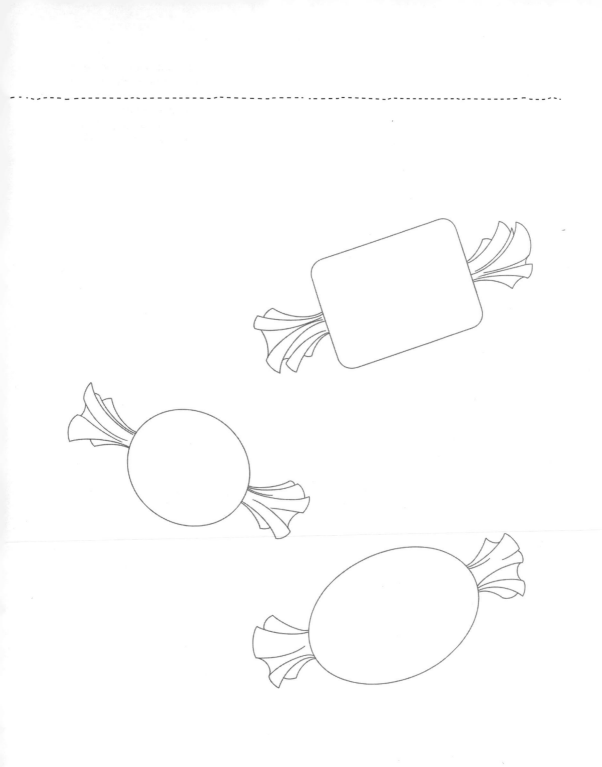

SIDEWALK BISTRO

Many people like to watch the city go by while enjoying a delicious meal. Use this bistro table as inspiration to draw your own sidewalk café scene.

Take It Further Your sidewalk café can be simple and calm, or complex and busy. As the artist, you get to decide how much detail to add. Look for images on the Internet if you need inspiration for what the scene might look like. Think of the tables, the windows, and what the restaurant's sign might look like.

RINGMAKING 101

Use these basic circles to draw different rings that might adorn your fingers or those of a friend or loved one. Add jewels, gems, and your favorite twenty-four-carat details.

BON APPÉTIT!

Re-create your favorite meal on this plate. Draw it, a glass of water, and silverware.

Take It Further Draw from memory or head to the kitchen and cook up your favorite meal (or use the meal you make for tonight's dinner). Look for the shapes and values the various foods create, and draw your meal. Think about how the meal will taste and convey that through how you draw it and the colors you use.

HAPPINESS IS...

Happiness comes from within and means something different to every individual. What makes *you* happy? Is it a person, place, or experience? Once you have your happy thought, draw it on this scrapbook page.

Take It Further Drawing from your imagination can be difficult. If you need inspiration or help with the details, look for an image or reference photo to use for your drawing. Use that reference photo to look for the shapes and values to create your drawing.

IN THE WOODS

Wooded lands are home to many types of plants and creatures. Draw the animals, plants, and trees you might see near this fallen log.

MOVE TO THE MUSIC

Dance is the full-body expression of a feeling or mood captured in movement. Think about how you feel and what your body looks like when you're dancing, and draw the body in motion here. To get some general direction or inspiration on what to sketch, watch yourself in the mirror or a video of someone dancing.

Take It Further For an added challenge, try practicing a gesture drawing. A gesture drawing captures the essence of an object with as few marks as possible, making it perfect for drawing people in motion. Use the side of your pencil lead to create bold strokes. Draw a few additional details to develop your drawing after the initial gesture drawing is complete, being careful not to lose the carefree essence of the dance moves.

CITYSCAPE

There's a certain frenetic energy in big cit-
ies. Transform this simple line drawing into
a bustling metropolis by adding details
to the buildings shown here, then adding
your own buildings. Or create a cityscape
of the future by creating an ultramodern
city.

Take It Further Use different thicknesses of pen
or pencil lines to create various details for each
building. Add windows, cornices, moldings and
trim, awnings, and maybe even a gargoyle!
Make each building unique by selecting a dif-
ferent style for each—Victorian, Arts and Crafts,
Art Nouveau, modernism. You are the architect
and can determine which styles you want to use.
Cityscapes are also a great way to explore tonal
color variations—different values of the same
color to create a subtle mood and a unified color
scheme. Use different values of browns, grays,
and other neutrals to form Arts and Crafts and
modernism scenes. Another approach would be
to create a color-filled environment using col-
ored pencils or felt-tipped markers for Victorian
or Art Nouveau city scenes.

ZOOFARI

To practice drawing unusual animals, take a trip to your local zoo. The animals will entertain and educate, while providing great subjects for drawing. Fill your zoo with your favorite animals.

Take It Further When drawing animal fur, think about how coarse the texture might be and adjust your drawing technique. To draw coarse or rough fur, use more defined lines and harder edges. For softer fur, use a lighter touch and softer edges.

WHAT'S IN YOUR FRIDGE?

Refrigerators are filled with all sorts of foods, as well as boxes, jars, and containers—in other words, they provide a perfect opportunity to practice drawing foundational shapes. Use the contents of your own refrigerator as inspiration and reference material to fill these empty shelves.

Take It Further Draw the items that appear in front first and then draw taller items behind so you can cram all of your favorite foods into this drawing. For a more environmentally friendly drawing, take a photo of the interior of your fridge instead of keeping the doors open.

PIECE OF CAKE

Think about the most amazing cake you have ever seen, or dream up your own version of the perfect cake. Draw the icing, piping, and other details to create your dream cake.

Take It Further Use a pencil to define the shapes of the cake and then apply the shading technique to give it shape and form—don't forget to think about the light source and add a cast shadow and some highlights. This cake is basically a series of cylinders you can give form to by using the shading technique. Use colored pencils to add colorful details like piping, an image, or writing.

GET YOUR FEET WET

Have you ever stopped to look at how beautiful and intricate feet are? Practice drawing your feet here—either crossed at the ankles or with one foot next to the other.

Take It Further For an extra challenge, try a contour drawing of feet. Put your feet up on a stool or chair, and cross your ankles so you can easily see them both. Imagining your pencil touching the outside of your left ankle, move the pencil up the page following the edge of your foot, moving toward the toes. Draw each of the toes and toenails with a smooth, even line. When you've finished with the left foot, keep your pencil on the paper and move to the right foot, drawing all the details. Capture any creases you may see as you draw both feet. It is okay to cross lines you've already drawn or to draw the same part twice.

PAPER MONEY DESIGN

To honor influential people who moved our country forward, we place their images on our currency. Draw your own currency here using miniature portraits of people you want to celebrate.

Take It Further Find photos of the people you want to place on your custom currency. For an extra challenge, consider drawing a profile or three-quarter pose. A three-quarter pose allows the artist to see three-quarters of the model's face—the profile and one-quarter of the remaining half face. (A profile will be easier to draw, so try the three-quarter pose after you've practiced a bit.) Design your currency with the image in the center and the monetary value in the corners. Don't forget to add meaningful text. Use actual currency as a reference.

SEA CREATURES

The oceans are filled with interesting and amazing sea life. Draw a pod of dolphins near the waterline and surround them with other creatures that can be found in the ocean.

Take It Further Plan your drawing so your dolphins are staggered and swimming in the same direction. This will create an invisible line for the eye to follow and evoke movement and motion in your drawing. Show some of your dolphins out of the water and others at various stages in the water so you see different body parts on different dolphins.

TIME TRAVEL

If you could go back in time, what era would you visit? Think about your favorite time period and location and draw some of the items you would find.

Take It Further As you draw the images from your time-traveling trip, think about how you place the items on the page. Make the more important images larger and the less important ones smaller to convey which ones hold the most significance. Add the month, date, and year to the digital clock to indicate the time period you are visiting.

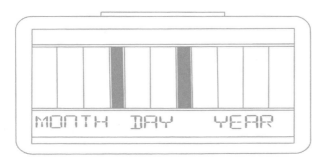

MONTH DAY YEAR

YOUR PERSONAL MOTTO

Many people have a personal motto or creed they refer to when times are tough or to help define themselves—perhaps "YOLO," "carpe diem," or "knowledge is power." Write your motto here and illustrate what it means to you.

Take It Further Consider placing the words of your motto in the center of the page and add some small drawings around it. Think about what colors resonate with your motto or have meaning for you.

I HEART...

What do you love the most? Reading books, creating art, cycling, weight lifting, your kids, your cat, your garden...or drawing? Think of how to capture that idea as an image and draw it within the heart.

Take It Further This is an opportunity to focus on one idea and transform that idea into an image. Think of the details you can include in your drawing to make it unique to you. Use the space around the heart to add secondary drawings that are related to what lives in your heart.

CAN YOU SPARE A DIME?

You may not have bank, but you can have some coin by designing your own metal currency. Collect any loose change you may have as inspiration and start drawing your own coins.

Take It Further Coins are actually small sculptures using the bas-relief technique—that's an artistic object sculpted with a very shallow depth. To capture this effect in a drawing, use a pencil to draw crisp lines and sharp edges (keep that pencil sharp!). Keep the value range limited and the shading to a minimum, and don't use any color (just the gray of the pencil lead).

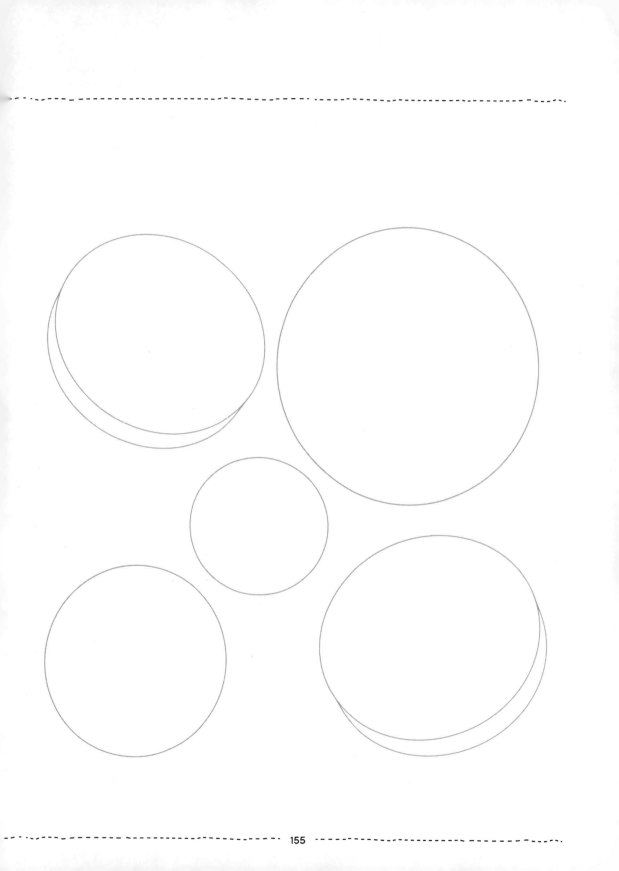

YOUR WORKSPACE

Most people spend many hours at work each week, most at a desk, table, or counter. Think about where you work and draw the objects that occupy your workstation. Or, to motivate yourself, draw your dream job's workspace.

Take It Further If you have access to your workstation and time to draw, consider capturing your workstation as a contour drawing. Start at one end of the flat surface and draw the items without removing your pencil from the paper. Or take a photograph with your phone to use as a reference and draw at your home.

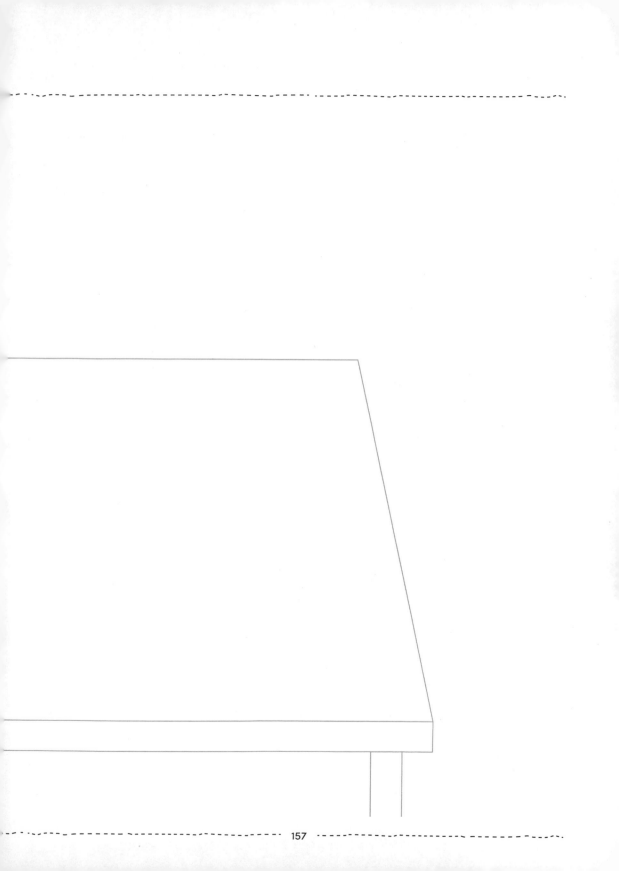

PULL UP A CHAIR

Everyday objects around you can provide endless opportunities for drawing subjects. Select your favorite chair and draw it.

Take It Further Think about what makes this chair different from others. Is the chair hard or soft? Is there fabric with a particular pattern, or does the wood have a certain grain pattern or sheen? Identify the lighting source and define the dominant shapes in the chair. Draw those shapes and add shading to create form based on where the light hits the chair. Include the shadows and cast shadow. Add the background once your chair is complete.

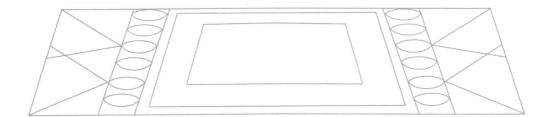

PLEASE BE SEATED

Drawing a seated person offers a great way to both practice your drawing and spend time with a friend. Ask a friend to pose for you or find a reference photo online of someone sitting to draw a seated figure.

Take It Further When drawing a person from life, make sure you place a strong light to one side to increase the highlights and shadows to make a more interesting composition for your drawing. Start by identifying the basic shapes—look for spheres and cylinders that make up your model. Use light pencil strokes to draw the basic shapes to develop your figure. Once you have the basic shapes and proportions correct, remove any unwanted lines using your eraser and darken the remaining lines with your pencil or go over them with your fine-tipped marker.

WINDOW WISHES

If money were no object, what would you shop for? Instead of spending actual money on your favorite wares, draw what you might see in your favorite store windows.

Take It Further Window displays can be simple or elaborate, so choose the style that works for your product. Draw your display using simple shapes and colors first. Then think about details like what's behind your display and what type of lighting is present to add realistic touches to your composition.

BY THE POOL

Create a cool, refreshing summer scene by drawing a pool. Think about what is happening inside the pool, as well as what is happening around it.

Take It Further Capture a light, summery mood using thin, confident lines and a light color palette, and leaving plenty of open spaces in your drawing. Sometimes using lines without shading is a better way to capture the mood of a scene. When only using lines in your drawing, the lines need to be clear and strong with well-defined shapes that accurately convey what your drawing represents.

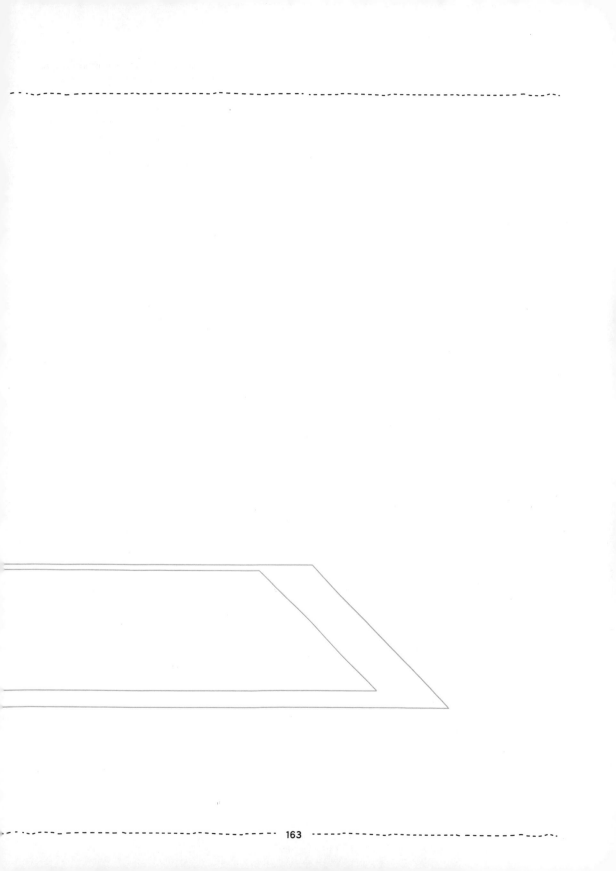

SET UP CAMP

Fresh air, communing with nature, and "roughing it" make camping a great break from everyday life. Think about what you'd take with you to set up a campsite, and draw it in this forest.

Take It Further Decide if you want to draw your campground during the day or night. Use a pencil to start your drawing and then select the appropriate colors and light or dark shades for day or nighttime.

OH MY, A PIZZA PIE!

Draw your favorite pizza here—don't forget about the toppings!

Take It Further You probably know what your favorite pizza tastes like, but what does it look like? Is the crust crispy or fluffy, and is it thick or thin? What do the toppings look like? Alter your drawing techniques to match the textures of your sketch: Use soft, rounded lines for the cheese. Use sharp, firm lines for a crispy crust. Use different values to help shade the pizza to create a realistic appearance.

I LOVE TO LISTEN TO...

Think of your favorite song or playlist and draw an image that captures that song. Or use an image of your favorite artist or music video as inspiration.

Take It Further Album covers are visual expressions of the music the artist has created. When re-creating your favorite album, look at the colors and images used to make the cover and the feelings they generate. Use a pencil and colored pencils to re-create those images and feelings.

A WALK IN THE PARK

Parks provide a chance to experience nature, a place to meet neighbors, and space to relax or exercise. Think about what you see on your trips to the park and draw them along this walking path.

Take It Further A path or walkway moves you from point A to point B. This is true in a drawing, as well as in real life. Think about how the subjects in your drawing move along the path to tell the story of your drawing. Draw an object at the starting point that your walkers are moving away from and draw the destination point they are walking toward (i.e., they may be leaving a picnic area and headed for a trailhead).

THE RHYTHM OF ROW HOUSES

Imagine a series of homes along a city street, or walk down a neighborhood street. Notice the various types of materials used on the outside (brick, siding, stone, etc.) and what type of window details you see. Use this outline for inspiration to create your own drawing.

Take It Further Draw each house to be a unique statement reflecting the personal style of the people who live there. Make each house different, but create harmony in your drawing by repeating common elements. Harmony (or unity) is important to draw a cohesive composition by using common elements that relate to one another. Harmony is important, but too much cohesion can make a dull drawing, so variation within the drawing adds interest. For example, the windows may all be the same size and position, but the trim and siding may be a little different—the window size creates harmony, and the different trim creates variation to hold the viewers' interest.

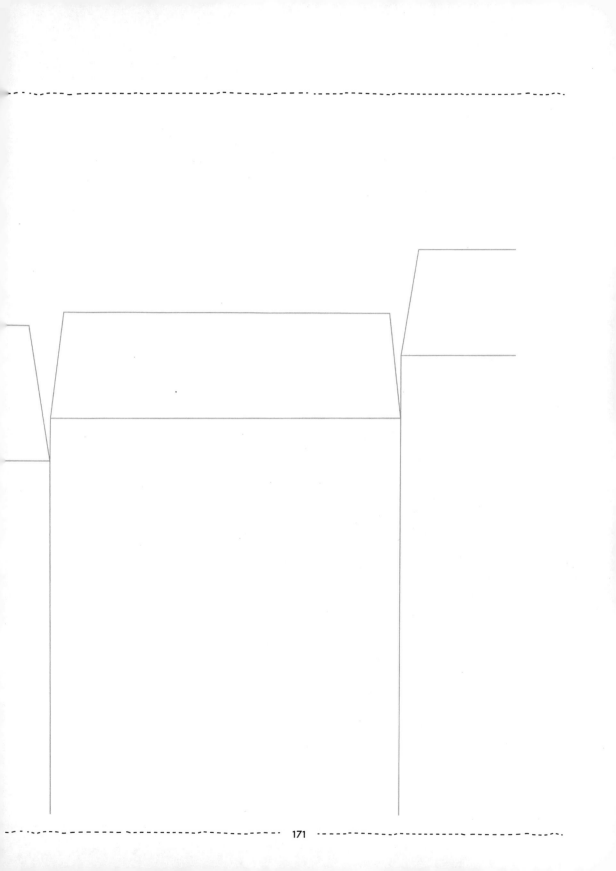

LET IT SNOW!

Draw a winter wonderland composed of objects that make the season special. Consider drawing snowballs, igloos, a snowman, snowshoes, boots, hats, or mittens.

Take It Further Make the more important items more prominent to create a visual hierarchy in your drawing. Add details using shading, texture, and color to make certain parts of your snow scene stand out. For example, you may want to have a snowman be the focal point of your drawing by making it the largest object and placing the less important items like the mittens, hats, and snowballs around it. You could use color only on the snowman and keep all the other items in black and white to create prominence as well.

DREAMLAND DOODLE

Think about your favorite dream (or what you'd *like* to dream) and draw it. Include details that tell the story of your dream.

Take It Further Dreams are stories from deep within our minds. Use a single image or several smaller images to draw your dream. Use looser, whimsical lines to create a dreamlike feeling.

GRAFFITI NAME

Use this brick wall to draw your name in graffiti-style lettering. Start by writing your name using a black marker, put an outline around it, then add another outline in a bright color (pink, yellow, orange, apple green). Try to get the colors to fade out.

Take It Further One of the hallmarks of graffiti drawing is the slow fade. *Fading* is just another term for "shading," but you will use it to create a halo effect around the lettering. This type of drawing can be dramatic and bold—a wonderful way to express yourself. Just keep it on paper and not on a neighborhood wall (unless you have permission).

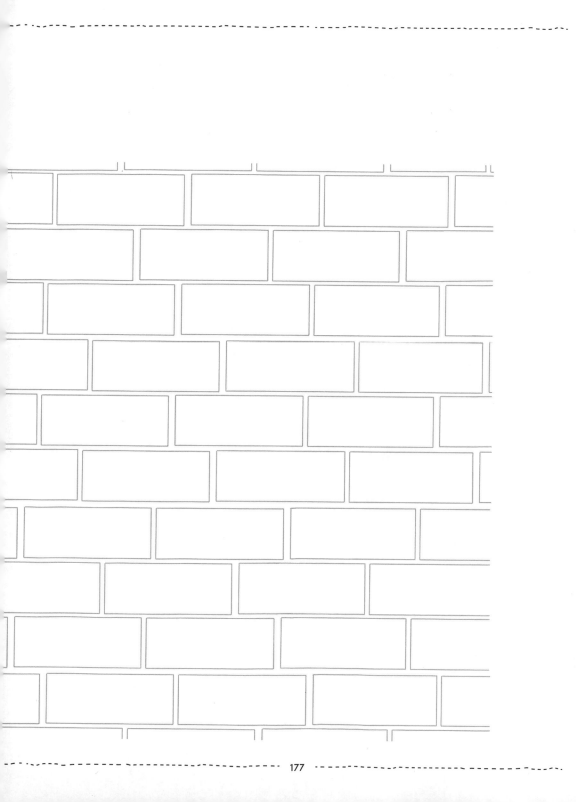

RAISE YOUR FLAG

Flags combine symbols and colors to represent a group, an organization, or even a country united under a common mission or goal. Think about your family, a club, or a friend group and create a flag that represents the group. What unites you? Use these flags to experiment with different designs to create your perfect flag.

Take It Further When designing a flag, composition is crucial. Think about two to three colors that represent your group and common mission. Do you want bold, aggressive colors like red and black? Calm and quiet blues and greens? Jarring oranges and yellows? Once you pick your color scheme, think about the shapes or single image that best complement your color scheme. Try a variety of compositions until you find the one you like best. Keep the composition simple and clear.

TERRIFIC TREES

Draw a tree by adding branches and leaves to this sturdy trunk. Decide if you want your tree to be budding in the springtime, fully leafed in summer, or showing glorious autumn colors.

Take It Further As you draw branches and leaves on your tree, leave some spaces to see through the tree to the sky. Consider tucking a bird's nest in one of the branches. Think about where the light hits your tree and add dimension by using shading. Use colored pencils to capture your chosen season's hues and add some variety of size to your leaves and branches.

YIN AND YANG

Yin and yang represent the concept of dualism, which is the idea that opposites can actually be complementary. There are parts within you that are opposing forces that work to make you who you are and are useful at different times. Think about two supposed opposite traits that you have and draw them in the yin and yang sections.

Take It Further Think about two aspects of yourself that are opposing forces (e.g., you like exercise but love candy, or have many friends but also like to be alone) and draw those using your pencil. Think about what colors might complement each of those traits—try to select colors for each aspect that contrast one another. Draw them in the yin and yang symbol using lighter colors for traits that you see as strengths and darker colors for those you see as challenges. The strong contrast in color and value will create a dramatic effect.

STEP RIGHT UP!

Cotton candy, the boardwalk, and stomach-dropping rides are just some of the things you'll find at your favorite amusement park or carnival. Design a roller coaster, merry-go-round, Ferris wheel, or favorite carnival ride. Surround your ride with riders, concession stands, or carnival games.

Take It Further Try a more whimsical approach for your carnival creation. Think about where you want to place your carnival ride and how much room you will need to create the entire scene. Use your pencil to lightly draw your carnival scene, making corrections with your eraser as you go. Once you have a pencil sketch you like, go over the lines you want to keep with a fine-tipped pen to complete a line drawing. Add color in select places to add a little interest and contrast.

MYTHICAL MONSTERS

According to Greek mythology, the gods once roamed Earth and interacted with humans and mythical creatures like Medusa, the Minotaur, and Cerberus. Create your own mythical scene by drawing the monsters of ancient Greece.

Take It Further Greek monsters often combined animal and human forms. Medusa was a woman with snakes for hair, the Minotaur had the body of a man and the head of a bull, and Cerberus was a multiheaded dog. Combining different human and animal features is still a common practice among artists today. Draw these Greek creatures or create your own by combining different animal features with human ones to create a mythical menagerie!

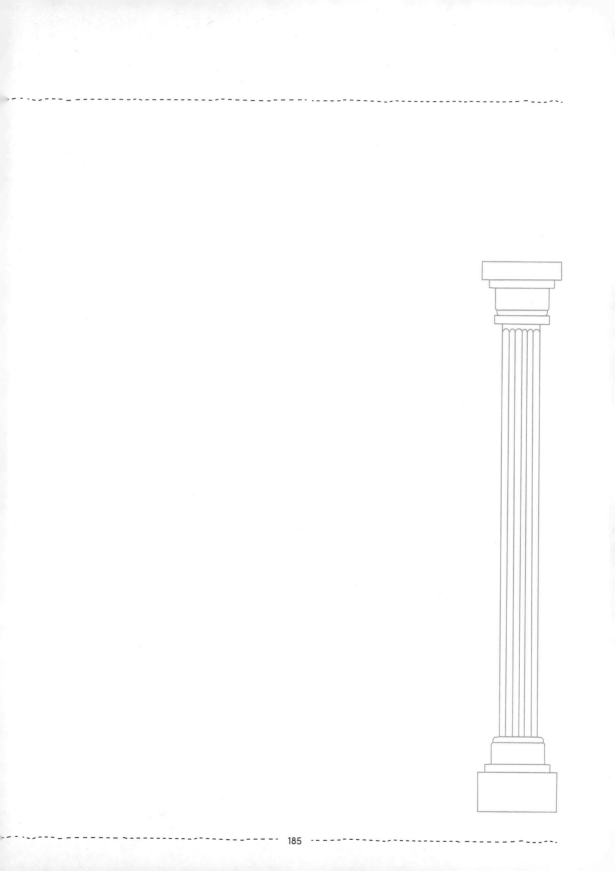

ROCK ON!

Music can evoke many different moods and feelings. Rock music has been inspiring people to express themselves for many decades. Design your own rock band and include different instruments—guitar, bass, drums, keyboards, horns, or any others that you'd like to draw.

Take It Further Keep your band small, perhaps four or five members playing their instruments and singing. Compose the drawing as if they are performing on a stage in front of a collection of dedicated fans. Use your pencil to sketch your band with lines only (no shading). Draw over your final pencil lines with a fine-tipped pen to finish your drawing. Erase any unwanted lines. Use a black-and-white color scheme to reinforce that rock and roll vibe.

ANOTHER SUITCASE, ANOTHER TRIP

Traveling provides the opportunity to learn about new places, meet new people, and have new experiences. Before you go on any trip, you pack for your excursion. Draw the items you would take with you if you were going on a grand adventure.

Take It Further Draw some items within the suitcase and others in the space around it. Don't forget logistical items like a guidebook or phone charger. Look to your closet for inspiration and pull out selected items for reference material so you can see how clothing looks when folded.

WHAT DOES YOUR FUTURE HOLD?

What do you dream your life could be? Who do you want to become? What are you hoping for? Think of a job or passion that you aspire to and draw your future within this crystal ball. Use the space around the crystal ball to write down what you need to do to make your dreams a reality.

Take It Further Just as an editor needs to limit words, an artist needs to limit what they are trying to capture. When working in smaller spaces like this crystal ball, be selective in what you are putting on the paper so that only the most important elements are included. You can add a mystical effect by lightly erasing your drawing as it reaches the edges of your crystal ball to create a fading or fuzzy effect.

CONCLUSION

I hope you enjoyed this collection of ideas and discovered the artist inside you! These prompts are just the beginning of your art journey—with continued practice you will be able to improve your drawing skills and achieve your goals. Drawing is like any other skill: The more you practice, the more improvement you will see. I encourage you to revisit these prompts and approach them with different techniques and styles.

As you grow as an artist, continue to challenge yourself with more difficult subjects to create more complex drawings. Once you are comfortable with drawing using a pencil and colored pencils, explore new materials. Be bold and try your hand at painting, using watercolor, acrylic, pastels, or oils. Mix things up with collage or digital art. Let your drawing practice be your launching pad into self-expression as you find your visual voice.

Continue to be curious about how to draw your favorite subjects, and challenge yourself to draw new subjects that may not initially appeal to you. Try new perspectives, different angles, or formats to create interesting compositions.

Most importantly, remember that art is a form of play. Embrace that younger, playful inner artist and give yourself permission to experiment, learn from any mishaps, and be unafraid of taking chances. Let art bring you happiness and joy as you have fun and follow your creative dreams.

Keep drawing!

ABOUT THE AUTHOR

Jamie Markle is an author, artist, and book editor with more than twenty years of experience in the publishing business. He began his career in publishing as an associate editor for North Light Books and quickly rose through the ranks by acquiring and developing content with key instructors in the art community. As vice president and group publisher at F+W Media, he was responsible for the creative and financial health of the fine art group, overseeing books, magazines, videos, online courses, and digital content.

He has worked with numerous editorial teams to create the following magazines: *The Artist's Magazine*, *Acrylic Artist*, *Cloth Paper Scissors*, *Pastel Journal*, *Drawing*, *Southwest Art*, *The Collector's Guide of New Mexico*, and *Watercolor Artist*. He oversaw the content direction for North Light Books and IMPACT Books, as well as videos produced by Artists Network.

Jamie is the author of ten books on fine art, including five books in the AcrylicWorks: The Best of Acrylic Painting series. With his partner, Paul Wesselmann, he has self-published two books, *Ripples for Reflection: Weekly Inspirations for Unleashing Your Best Self* and *Ripples of Hope: Wisdom for Navigating Uncertainty*.

Jamie holds a degree in fine art from Xavier University, where he studied painting and drawing. In addition to making art, gardening, and writing, he enjoys indulging his sweet tooth, which he counteracts by running six days a week. He spends his free time working on the hundred-year-old home and garden that he shares with Paul in Cincinnati, Ohio.

You can find Jamie on *Facebook* at Facebook.com/Jamie.Markle and follow him on *Instagram* at @jamiemarkle.